Figures in Watercolour

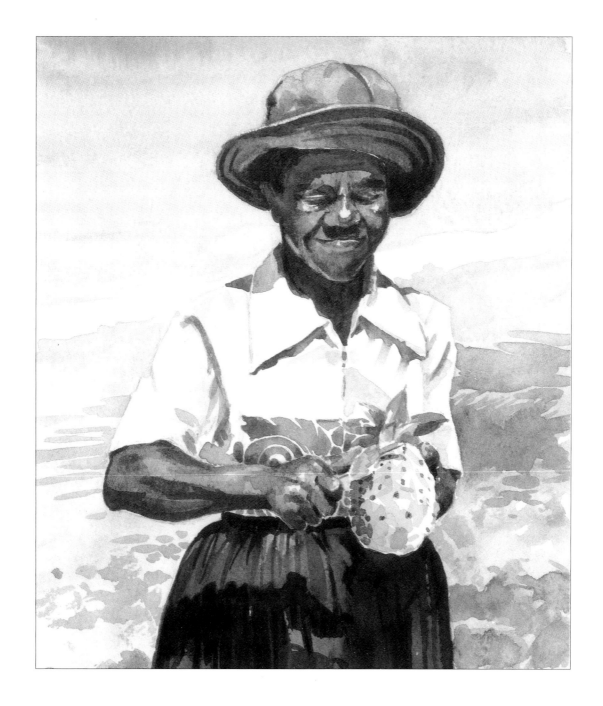

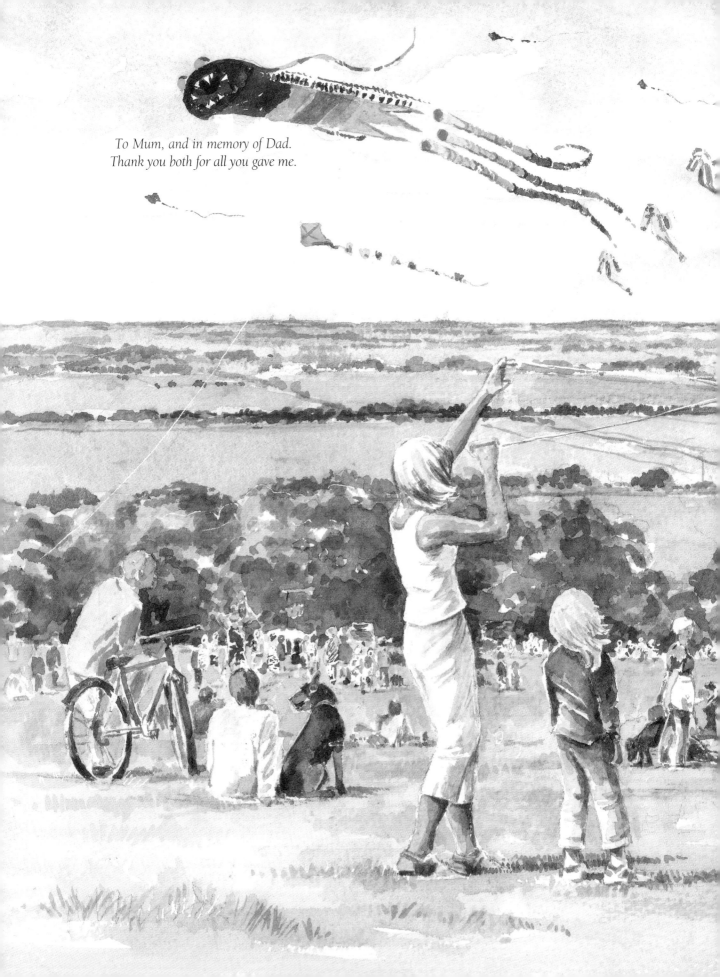

To Mum, and in memory of Dad.
Thank you both for all you gave me.

Figures in
Watercolour

CAROLE MASSEY

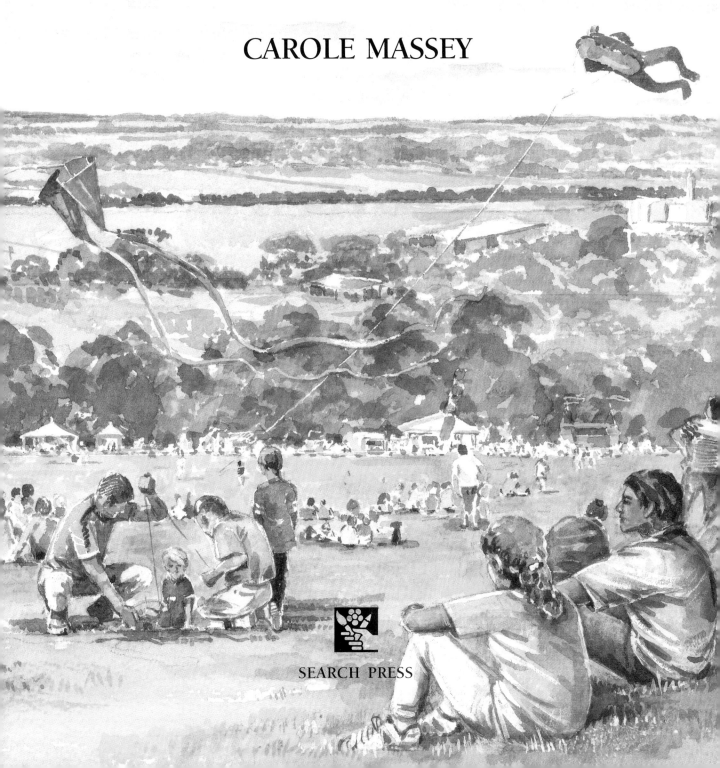

SEARCH PRESS

First published in Great Britain 2003

Search Press Limited
Wellwood, North Farm Road, Tunbridge Wells, Kent TN2 3DR

Reprinted 2005

Text copyright © Search Press Ltd. 2003

Photographs by Lotti de la Bédoyère, Search Press Studios
Photographs and design copyright © Search Press Ltd. 2003

ISBN: 1 903975 03 4

The publishers and author can accept no responsibility for any
consequences arising from the information, advice or instructions
given in this publication.

Suppliers

If you have difficulty in obtaining any of the materials and
equipment mentioned in this book, then please visit the Search
Press website at **www.searchpress.com** for details of suppliers.
Alternatively, you can write to the publishers at the address above,
for a current list of stockists, including firms which operate a mail-
order service.

Publisher's notes

All the step-by-step photographs in this book feature the
author, Carole Massey, demonstrating how to paint figures in
watercolour. No models have been used.

The painting on page 27 was based on a photograph taken by
Peter Teigen, and is reproduced with the permission of the
Bird College of Dance and Theatre Performance in Sidcup,
Kent. The dancer, Lucy Bennett, graduated from the college
with a First Class Honours degree in 2001.

There is a reference to sable hair and other animal hair brushes
in this book. It is the publishers' custom to recommend
synthetic materials as substitutes for animal products
whenever possible. There are a large number of brushes made
from synthetic materials available, and these are just as
satisfactory as those made from animal fibres.

Printed in Spain by A. G. Elkar S. Coop. 48180 Loiu (Bizkaia)

My grateful thanks to Ally, Roz and the Search Press
team for making it all happen again; to my painting
pals Sue and Rachel for all their support and
encouragement, to Charity for her invaluable help
and to Eric for his unfailing belief in me.

Cover:
My Kite

*I did this study of a small group while sketching for my
painting of the kite festival (see pages 2/3). Though they do
not appear in the final painting, the expressions and body
language of the mother and child tell their own story.*

Page 1:
Pineapple Lady

*Set against the backdrop of the turquoise sea and dazzling
sand this charismatic figure makes an evocative picture. The
deep blue shadows help to create the feeling of heat and light.*

Page 2/3:
Kite Festival on the Heath

*I did lots of sketches and took photographs to create this
composition. The two main standing figures are placed about a
third in from the left for maximum impact. The groups of
figures to the right and left help to lead the eye in to the picture.
I painted quite loosely on Not paper and tried to maintain a
'sketchy' feeling throughout, keeping a sense of activity without
becoming involved in too much detail of individual figures.*

Page 5:
Spanish Clowns

*A moment of magic originally captured in photographs makes
a charming composition. The stance and attire of the female
clown convey her character and humour.*

Page 6:
Sleeping Baby

*The colour variations on the delicate baby's skin are very
subtle. I used peach-tinted paper, and raw sienna and
permanent rose as the basis for the skin colour, adding cobalt
for the cooler shadows. This subject has the 'aah' factor!*

Page 7:
Nathaniel

*The stripes on the clothing act like contour lines describing the
shape underneath, drawn tightly round the arms and
shoulders and falling loosely round the body.*

Contents

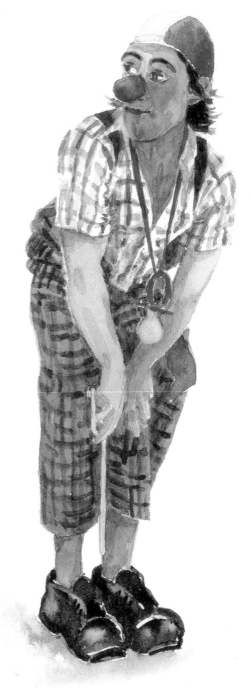

Introduction

Painting the human figure can be daunting, and watercolour is possibly the most difficult medium to work with. This book aims to show that the human figure is really no different from any other subject matter: it is simply a question of learning to draw what you see, not what you think you see.

It is true that drawings and paintings of people can be complicated by the desire to represent character, movement and expression. Of course any errors are more obvious, because the human eye is automatically drawn to a figure in a painting. This is precisely why figures add so much to a composition: they act as a focal point, adding warmth and interest and turning an observation into a story.

The book tackles specific areas of figure work in turn, introducing the basics of anatomy and proportion, focusing for example on colour mixing for flesh tones, studying heads and hands, providing helpful hints on tackling movement, demystifying the process with clear, step-by-step demonstrations progressing from initial sketches to a final painting.

Start simply, working from photographs if you find it easier, then sketching from life when you have built up more confidence. Do lots of sketches to familiarise yourself with your subject. When you are ready to start painting, work out the tones and composition by making a small thumbnail sketch first. Keep a sketchbook with you at all times and make lots of sketches. Jot down written notes so you can recall details of the scene to paint later. Look out for painting subjects wherever you are. The most important thing is to keep practising.

Above all, the aim of this book is to simplify and to encourage. We see people in all shapes and sizes around us everywhere. Capturing them successfully in our paintings is a delight. I hope that this book gives you the confidence to begin.

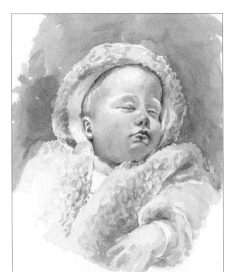

Carole

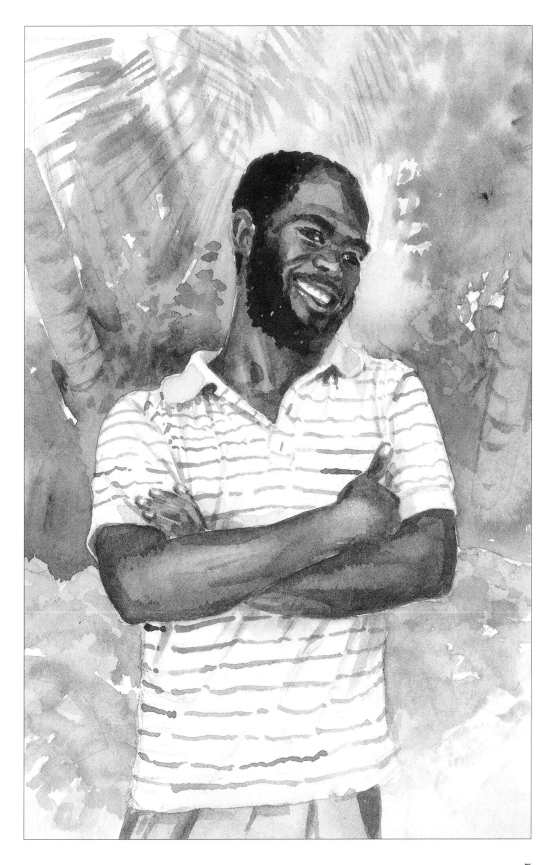

Materials

There is a bewildering array of goodies available in art shops, which can be quite confusing for a beginner. To start painting you really only need a brush, a few paints, paper, a palette and water. It is best to start simply with between six and ten colours. Like any craftsman, you need good tools to work with, so I always advise students to buy the best quality they can afford: artists' quality water colours, and one or two good quality brushes. Semi-rough 300gsm (140lb) paper is ideal. As you progress, you will no doubt want to add other colours, try out different sizes and shapes of brush and experiment with various paper surfaces, which will extend your range of effects.

Paper

I use a good quality medium surface 150gsm cartridge paper, ideal for sketching, small watercolours and pen and ink.

Watercolour paper is made in three finishes: HP or hot pressed which is smooth, Not or cold pressed, which is semi-rough, and Rough. Different thicknesses are measured by weight.

I usually paint on 140lb (300gsm) paper which I stretch first to prevent the surface cockling. For the paintings in this book I have used papers produced by different manufacturers. These give a variety of results, so do experiment with different types.

Stretching paper

To stretch paper, you will need a drawing board and 38mm (1½in) wide brown gum-strip paper. Paper stretched in this way will always dry completely flat.

Wipe over the board with a damp sponge and lay the paper on. Wet the surface of the paper, pushing out any creases. Moisten a length of gum-strip paper with the sponge and stick it along one side, overlapping the edges slightly. Repeat on the remaining sides of the paper, making sure that the gum-strip is stuck down. Leave it to dry, then remove from the board by cutting between the paper and the gum-strip with a sharp knife.

Brushes

My most-used brush is a No.8 round, a synthetic and sable blend. I use a No.5 sable for more detailed work and a No.20 round for big washes. In addition I sometimes use a small squirrel mop or a rigger, depending on the type of mark I want.

Paints

Paint in tubes is fluid, so mixing up larger quantities is easier. For working outside, pans are less messy. If you buy a set of paints, do not be tempted to use all the colours: your painting will look much better if you limit yourself to eight or ten. It is worth paying a little extra for artists' quality.

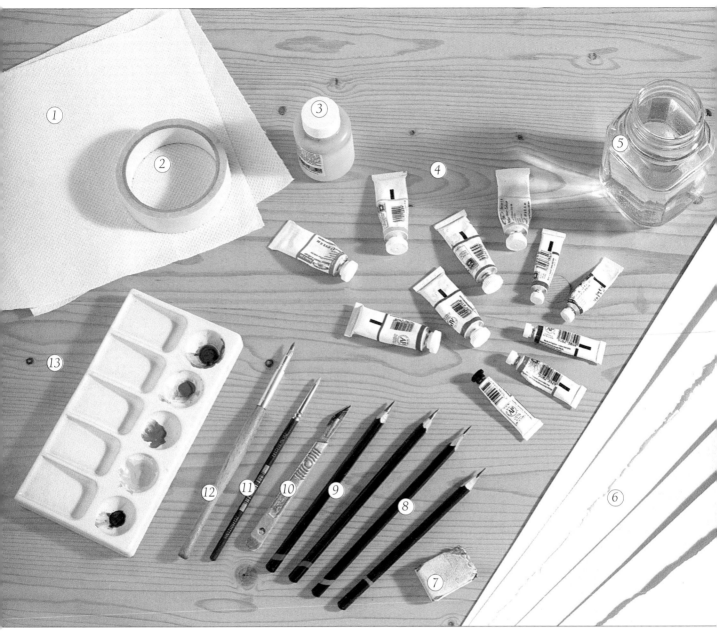

1. **Absorbent paper** for mopping up spills and lifting out paint.

2. **Masking tape** for securing work to your drawing board.

3. **Masking fluid**.

4. Artists' quality watercolour paint in tubes.

5. **Water pot**. I use two: one for rinsing out dirty brushes and the other for mixing colours.

6. A range of **papers** including Not, tinted Not, semi rough, HP, cartridge and pastel papers.

7. Kneadable **putty eraser** which can be shaped and erases pencil marks without leaving residue.

8. **Pencils**: B and 2B.

9. **Water soluble graphite pencils:** medium and dark wash.

10. **Craft knife** to sharpen pencils.

11. **Silicone shaper** for applying masking fluid

12. **Dip pen** which can also be used to apply masking fluid

13. Small **plastic palette** - I use two or three of these.

Proportions

No two people are the same – thank goodness – and proportions will
vary a great deal. It is still useful to be aware of 'standard' proportions.
These guidelines will help you to achieve a drawing which looks 'right'.

 The head is generally used as the unit of measurement and, as a
rough guide, the height of a standing adult is approximately seven
times the depth of the head, chin to hairline, or 1:7. This can vary from
1: 6 to 1:8 for an exceptionally tall person. The diagrams below show
how the proportions change from about 1:4 in a child aged five or six to
about 1: 6 for an 11-year-old.

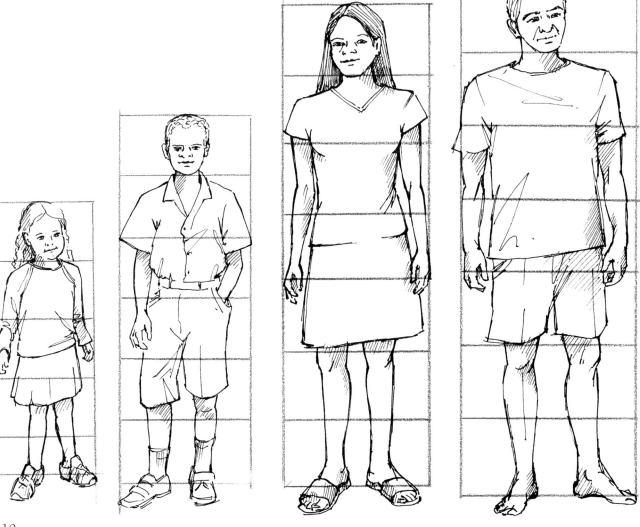

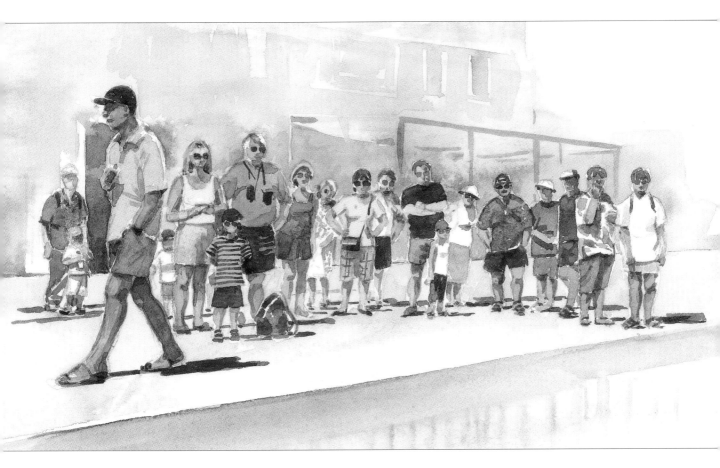

Waiting for the ferry

I did some sketches from the boat and painted this small study later. Body language can say a lot about a group of people. I like the contrast between the line of people standing and waiting to board the ferry and the movement of the passing figure.

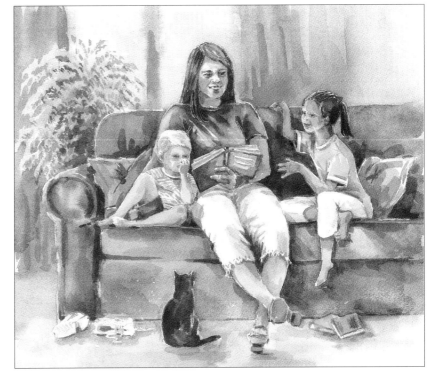

Family group

I incorporated two sketches which I did in an airport lounge to form the basis of this composition, placing them in a domestic setting to add more interest.

11

Anatomy

The study of anatomy was once the foundation of an artist's training. For centuries, artists studied and even dissected corpses to understand the workings of the bones and muscles, in order to improve the realism of their drawing.

Though nowadays we tend to draw what we can see, if we are also able to draw what is known it will add to our interpretation of the human figure. Knowledge of how the muscles pull, stretch and support the skeleton will help you to achieve better paintings, even if you plan to clothe your figures.

The way material drapes over a figure can help to describe the underlying form; the lines of the creases around the leg or arm will indicate the shape of the limb beneath. Fabric can stretch and crease around and over the knee or elbow, or hang loosely away from the body elsewhere. Distortions of simple patterns will, if carefully observed and drawn, also show form. Stripes can be used as effective contour lines. Remember that different fabrics, for example silk or denim, will fall and fold differently.

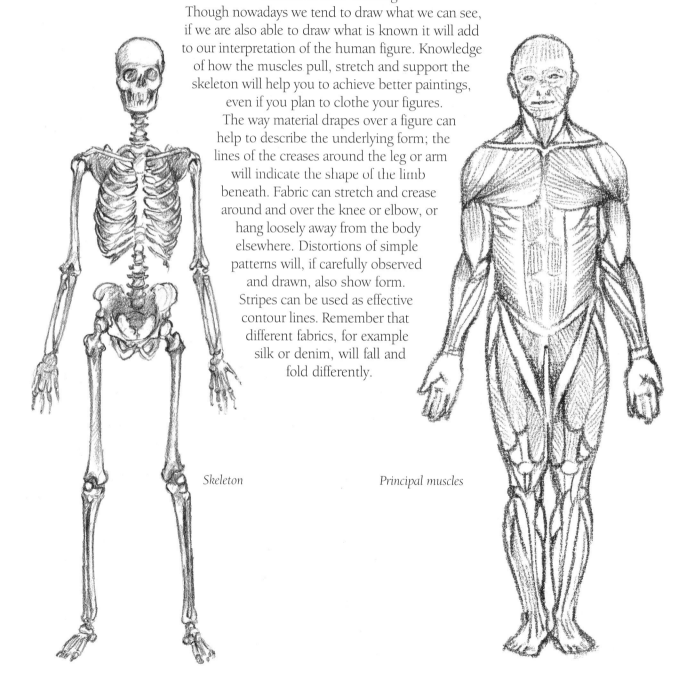

Skeleton

Principal muscles

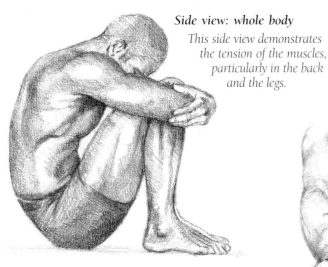

Side view: whole body

This side view demonstrates the tension of the muscles, particularly in the back and the legs.

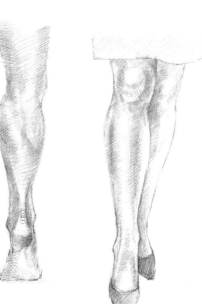

Upper torso: shoulders and neck

In some places, the bones are just under the surface of the skin; in others, the soft tissue creates rounded contours.

Arm

This foreshortened view of the arm shows the hand wider than the bicep muscle.

Upper arm muscles

This shows the defined structure of the bicep and shoulder muscles (deltoids)

Leg

This rear view shows the tension in the calf muscles.

Leg

This front view shows the contours of the knees and shins.

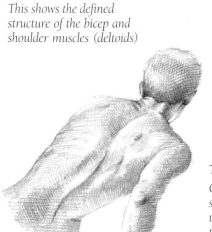

Twisting spine

Capturing the curve of the spine accurately is vital to understanding how the rest of the body is positioned.

Reclining figure

Note how the shoulders and the hips are at opposing angles.

Heads

It is helpful to think of a head as basically egg-shaped, pivoting on a cylindrical neck. Much of the face is covered with only a thin layer of tissue, so it is important to understand the underlying structure of the skull. Areas such as the forehead and temples, the side of the face and nose can be quite flat in contrast to the rounded contours of the lips and nostrils. If you want to achieve a good likeness, the distance between the features is perhaps even more important than the shape of the features themselves. The eyes are positioned on a line halfway between the top of the head and the chin, and are about the width of an eye apart. The ears align with the eyebrow and the base of the nose, and the corners of the mouth fall almost under the centre of the eyes.

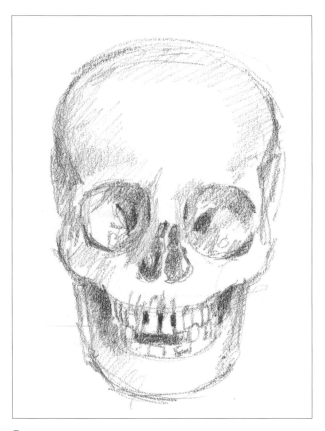

Bone structure
The structure of the skull gives shape and definition to the head and dictates a person's features. Judging the correct distance between the features will enable you to achieve a good likeness.

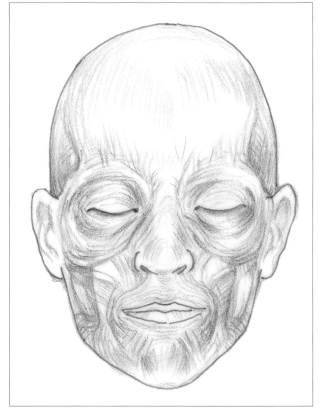

Facial muscles
This diagram shows a simplified version of the complex facial muscles. Although it is not necessary to know them all, it helps to be aware of them when painting.

Features

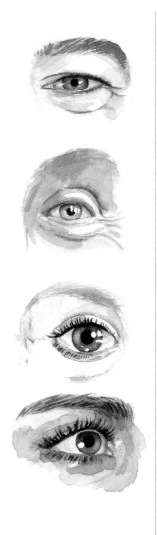

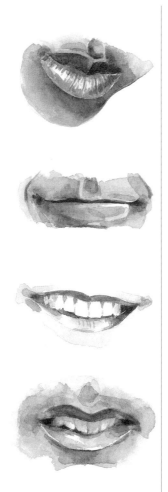

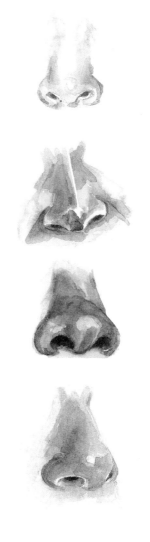

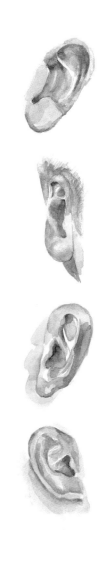

Eyes

The eyes really are 'the windows to the soul'. They are spheres which are set back into the skull. The iris is usually partially covered by the lids, unless an expression of surprise or alarm is being registered. Often, when a person is laughing, hardly any of the eye can be seen. Adding an extra touch of red to the tear duct will make the eye come alive.

Mouth

The mouth gives the face much of its character and shows expression: happiness; anger; sorrow; surprise. In normal light, the upper lip is usually in shadow and much darker than the bottom lip which often has a highlight. If you are painting teeth, treat them as a block rather than as individual teeth.

Nose

Noses can vary more than any other feature: from long, thin and pointed to large and bulbous. The length is about one-third the overall depth of the head. The shape and position of the highlight is important as it describes the structure and contours, while the shadow underneath the nose shows its projection from the rest of the face.

Ears

Pay as much attention to the painting of the ears as to the rest of the features, as they define and add balance to the head. The ears line up with the top and bottom of the nose, and are set back further on the head than you may think.

Hands

Gestures can reveal as much as facial expressions, so hands are very important. The beginner is often tempted to make them too small. As a guideline, the measurement from fingertip to heel should equal that of forehead to chin. Do not become bogged down in too much detail, because the further away the figure, the less detail will be required.

The diagram to the right shows how to simplify the shape of the hand. Only when the proportions are correct should you attempt to add detail.

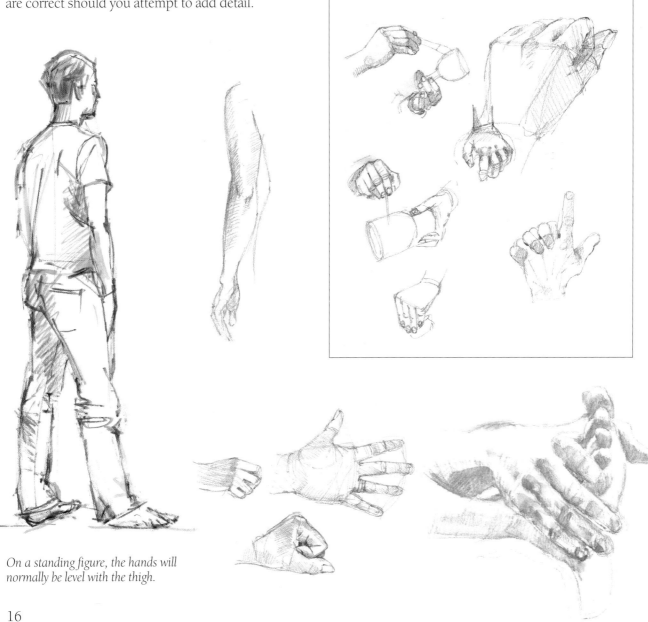

On a standing figure, the hands will normally be level with the thigh.

...and feet

As with hands, start by studying the overall abstract shape of the foot. You can practise drawing your own feet using a mirror. Note that the ankle is higher on the inside of the leg than the outside, and that the top of the foot forms a flat, triangular tilting plane. Pay particular attention to the arch and the contact points on the ground.

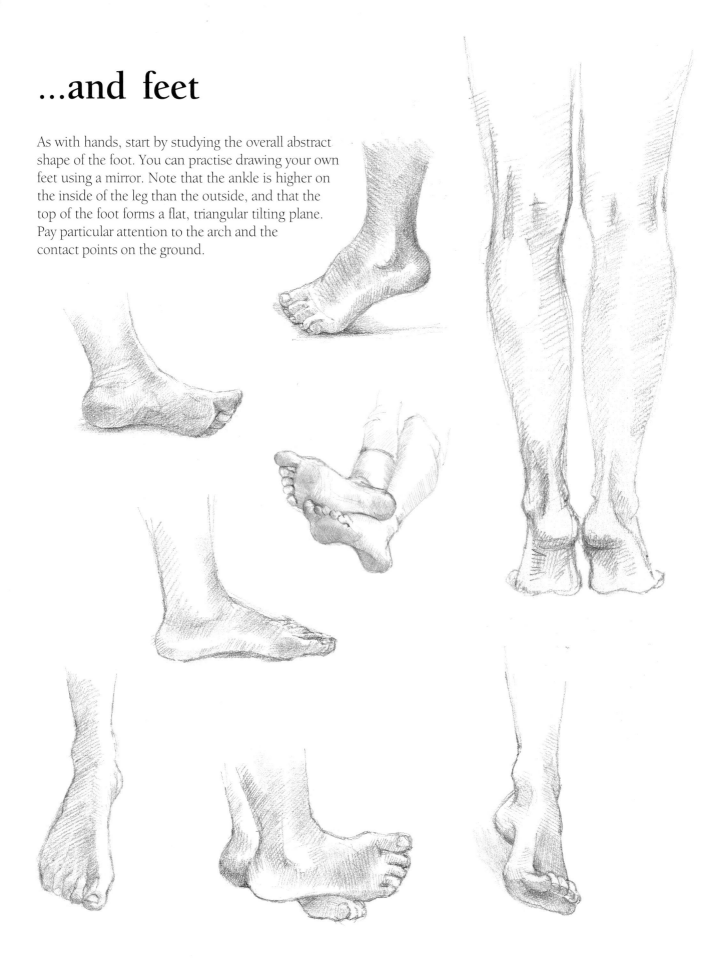

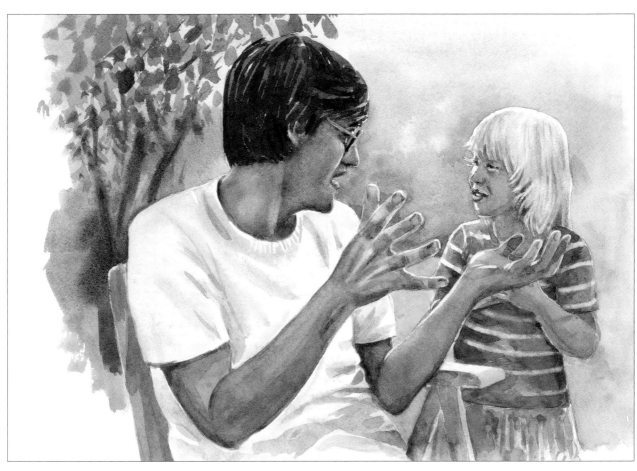

Father and child

Here is an example of the hands telling as much of the story as the facial expressions.

Mother and child

Although the child's head is smaller than his mother's, it is much larger in proportion to his body. Note also how large the child's head is in comparison to his shoulders.

The coach

*I masked out the highlights on the eyes,
eyebrows, and stubble with a fine pen
and masking fluid, and used alizarin
crimson with burnt sienna or raw
sienna for these rich brown skin tones,
adding ultramarine and alizarin
crimson for the shadows. The shirt is
Payne's grey and cadmium red.*

from a photograph by Phil Surbey

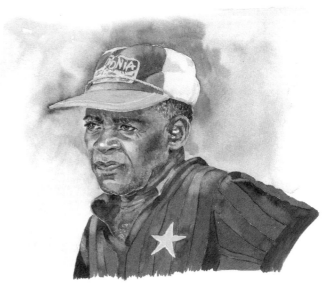

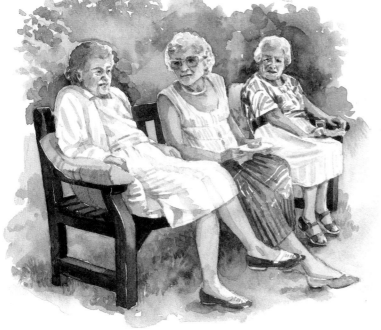

Old friends

*It is wonderful when you are able to capture a
special moment in a painting. Body language tells
the story of this reunion of three old friends.*

Lotti

*In this portrait, the hands are of secondary
importance, so I deliberately painted them in
paler tones than the face. Both hands are
foreshortened as they curve round the glass.*

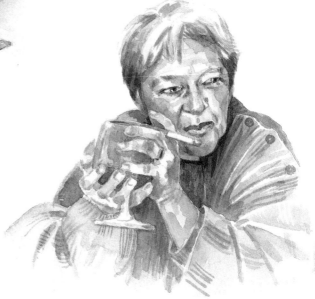

Colour mixing

There are many variations in skin and hair colour, which are often determined by ethnic origin. Pale skins may have greenish shadows, whilst dark skins have blue or purple shades. Avoid using pure black for darker areas as it will make the skin look dirty. Always try to mix your own shadow colours. Highlights and shadows give shape and definition to the features and help produce a likeness. Highlights can be white, or pale pink and on very dark skin may be a cool pale blue.

It is particularly important to identify the warm and cool areas of the face, areas such as the tear duct of the eye, the ears, and some of the nose can be made warmer to heighten realism. Remember, when introducing a colour, that it should also appear somewhere else in the painting, rather than in isolation.

The colour wheel

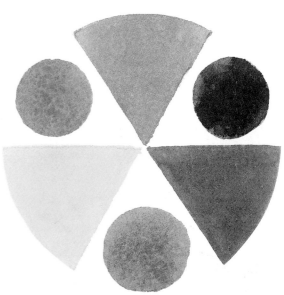

Primary colours (red, yellow and blue) are those which cannot be created by mixing other colours.

Secondary colours (purple, orange and green) are made by mixing two primary colours.

Complementary colours are opposing, yet harmonious groups of colours which can be used to enhance one another or mixed to give a good range of greys and browns. They are found opposite each other on the colour wheel: blue – orange; red – green; yellow – purple.

My palette

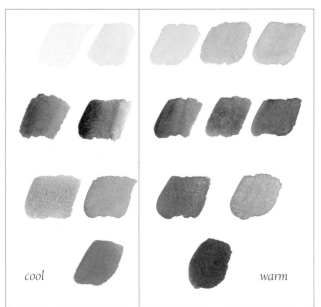

cool

warm

Yellows:

(left to right) lemon yellow, aureolin, cadmium yellow, yellow ochre, raw sienna

Reds and browns:

(left to right) permanent rose, alizarin crimson, cadmium red, light red, burnt sienna

Blues:

(left to right) cerulean blue, phthalo blue, French ultramarine, cobalt blue

Extra colours:

viridian, burnt umber

Cool and warm colours

Knowing how and when to use warm and cool colours will increase your scope.

Skin colours and shading

The colour of skin will vary a great deal from the palest yellows, through to pinks, browns and ebony, and will depend on age, ethnic origin, and climate. Shadows on skin will be made up of complementary colours – a trace of green on a pink jawline, a blueish or purple shadow on a brown or dark skin.

These colour swatches show some of the colour combinations I have used in this book to paint people of different ages and ethnic backgrounds. Beneath each one, I have shown colours suitable for use on cooler or shaded areas of skin.

Page 6	Pages 19/45	Page 18	Page 7
Baby Sleeping	*The Coach Jump*	*Mother and Child*	*Nathaniel*

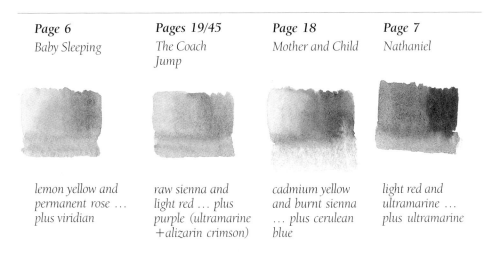

lemon yellow and permanent rose ... plus viridian
raw sienna and light red ... plus purple (ultramarine +alizarin crimson)
cadmium yellow and burnt sienna ... plus cerulean blue
light red and ultramarine ... plus ultramarine

Note

Areas such as the nose, ears and the tear duct of the eye will be much warmer in colour than the rest of the face.

Try mixing some colour combinations of your own, using no more than two primary colours at a time from the range on the page opposite.

Mixing blacks and greys

Using ready-mixed black from a pan or tube of paint can often result in dull or uninteresting colours. I prefer to mix greys and blacks from the complementary colours in my palette. Blues with red or brown, or green with pink, for example, can produce far livelier neutrals and dark hues.

cerulean blue cadmium red
viridian permanent rose
ultramarine blue burnt sienna
phthalo blue light red

Sketchbook work

Drawing people may seem daunting at the beginning, but the more you practise, the easier it will become. Sketching people from life fixes them in your memory far better than taking a photograph. Start by drawing family members or friends, reading or watching television. When you feel more confident, you can attempt to tackle less passive activities. Do not worry about making mistakes, capturing a likeness or putting in too much detail. A sketchbook is your private notebook – it does not have to be perfect! You can also jot down details of colours, quality of light, weather conditions and time of year, as reminders for future reference.

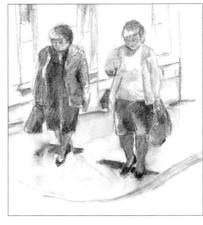

Shoppers
Notice how the feet are on different levels to indicate the motion of walking.

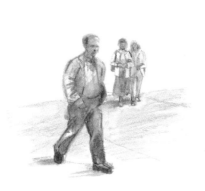

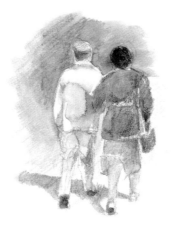

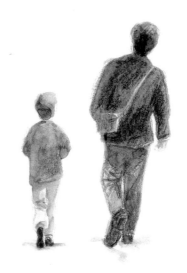

Walking figures
I made these quick sketches in a shopping centre, concentrating on the positioning of the legs and feet to interpret movement.

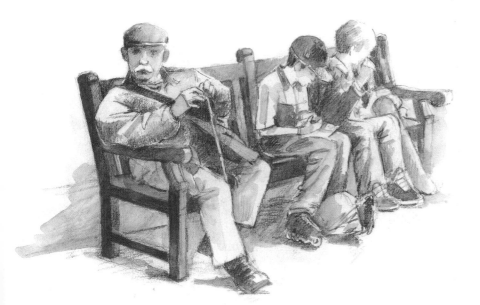

Note
Half-closing your eyes will help to simplify shape, detail and tone.

The generation gap
This sketch was started using water soluble graphite to which I added water to increase the tonal range. I liked the contrast between the old man, intently watching the passing shoppers in the busy market place, and the young lads engrossed with their roller blades and skateboard.

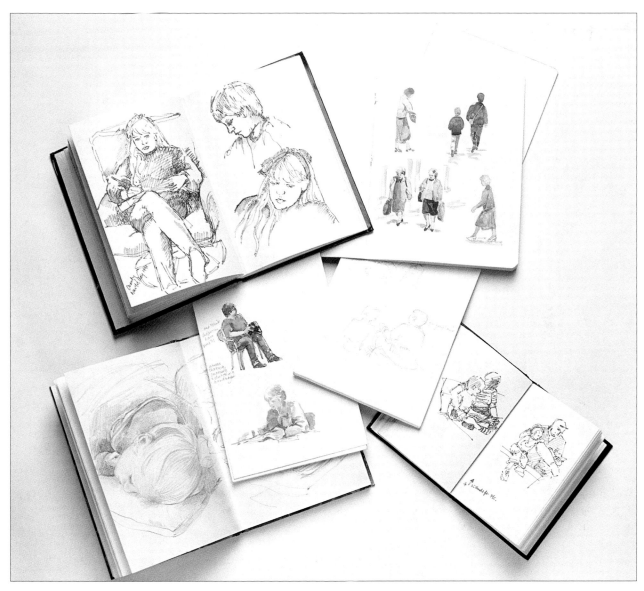

My sketchbooks

I use different-sized sketchbooks with varying grades of paper depending on location and medium. When you are working in public places, try to position yourself somewhere where you will not be noticed or disturbed.

Note

When you draw, try not to leave figures floating in space or your painting will have no sense of atmosphere or scale. Always add a few lines to suggest their surroundings.

Using sketches

These sketches were made as preparation for the painting on the right.

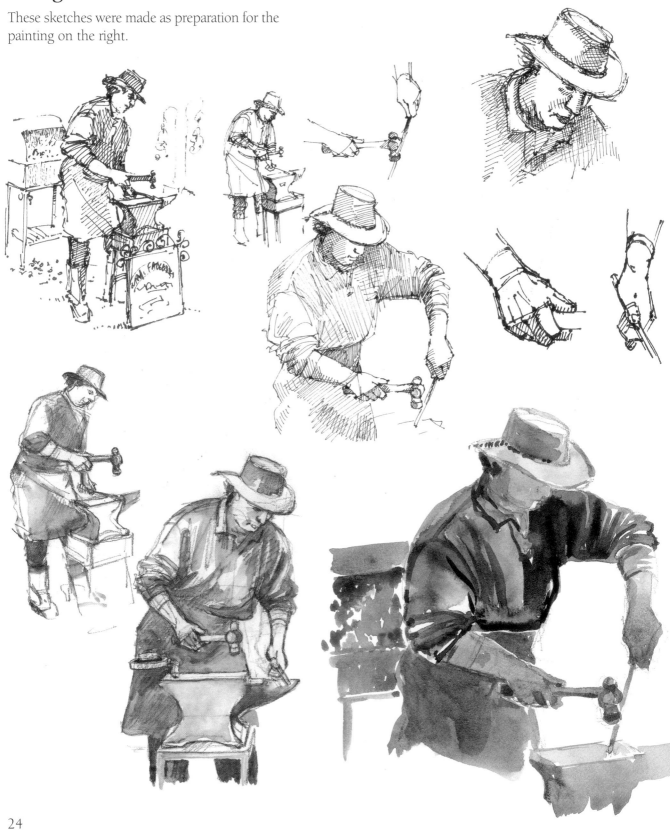

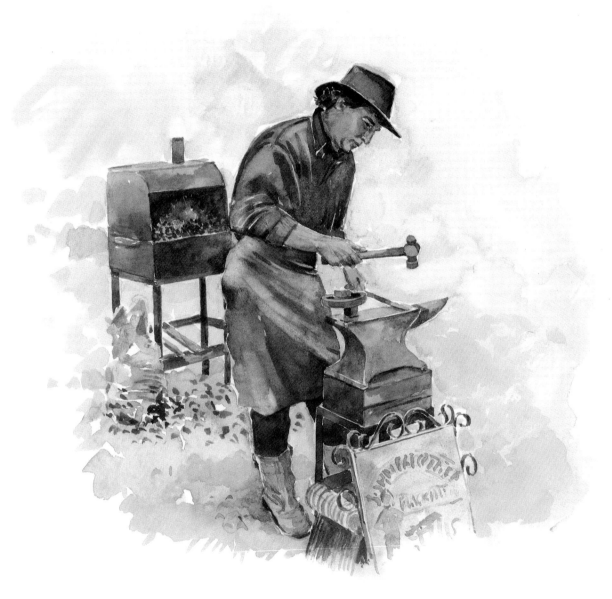

The Blacksmith

*This chap was a real showman, and when I asked if I could
draw him, he was only too pleased and immediately donned his
hat, which made him look even more appealing.
I made lots of sketches, and took photographs of the brazier
for reference.*

Movement

When you draw a figure in action, you are forced to concentrate, and consequently your powers of observation increase. Sometimes the process of observation and recording alone is more important than the end result.

The best way to learn to draw a moving figure is to start by simply observing. Some movements are repeated frequently, so look for lines and shapes that summarize the action. Keep your sketches and paintings small, so that you cannot be tempted to put in too much detail. Draw the first lines very lightly and you will be able to correct your work with heavier lines as you progress, and not use an eraser.

If you plan to paint over your sketches, try not to use an eraser too much as this may damage the surface of the paper. When you are more confident, you will be able to draw with your brush and eliminate the need for pencil guidelines.

Rehearsing
These quick pen and ink sketches of figures capture the dynamism of the dance. I added shading to give tone and form.

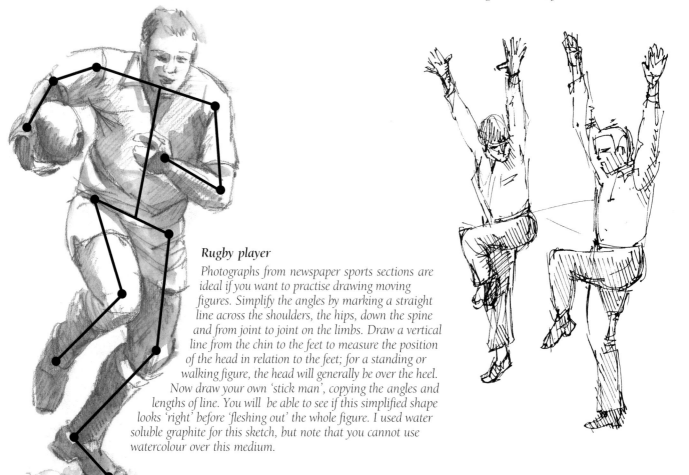

Rugby player
Photographs from newspaper sports sections are ideal if you want to practise drawing moving figures. Simplify the angles by marking a straight line across the shoulders, the hips, down the spine and from joint to joint on the limbs. Draw a vertical line from the chin to the feet to measure the position of the head in relation to the feet; for a standing or walking figure, the head will generally be over the heel. Now draw your own 'stick man', copying the angles and lengths of line. You will be able to see if this simplified shape looks 'right' before 'fleshing out' the whole figure. I used water soluble graphite for this sketch, but note that you cannot use watercolour over this medium.

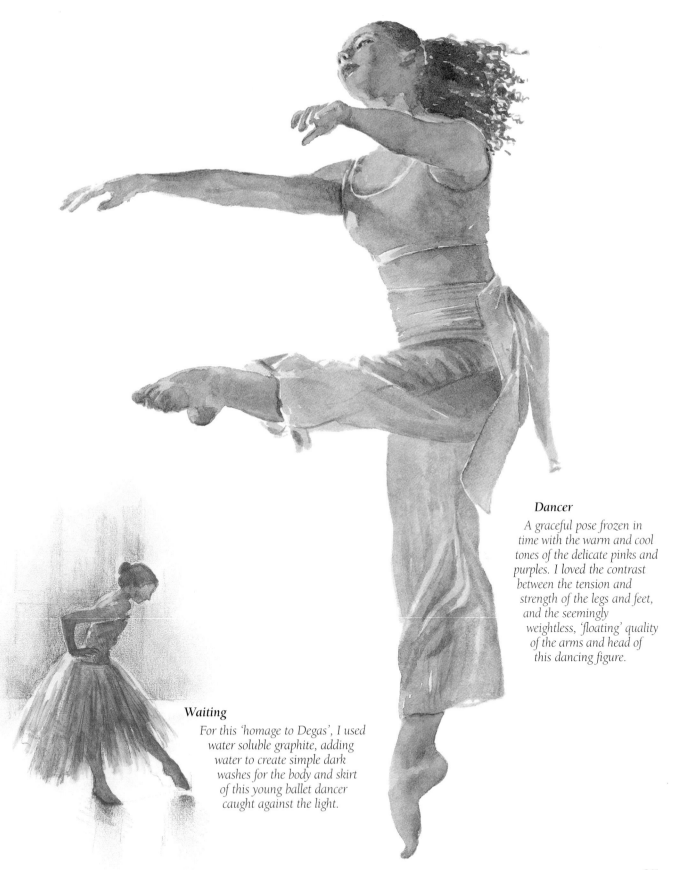

Dancer

A graceful pose frozen in time with the warm and cool tones of the delicate pinks and purples. I loved the contrast between the tension and strength of the legs and feet, and the seemingly weightless, 'floating' quality of the arms and head of this dancing figure.

Waiting

For this 'homage to Degas', I used water soluble graphite, adding water to create simple dark washes for the body and skirt of this young ballet dancer caught against the light.

Composition

When you include figures in a composition, overall shape and stance is much more important than detail. A focal point of one or two people with clear body language will tell a story and, if well observed, will make your painting believable. If you are working from life, you may want to sketch lots of people, then arrange them into a suitable composition. (See Kite Festival, pages 2-3).

If you work only from photographs you may need to make adjustments, moving figures away from awkward background details so lampposts do not grow out of heads or people walk off the edge of the picture, or combine figures from several photographs to create the ideal composition. Avoid putting a large figure right in the middle of the painting, instead placing it to the right or left of centre.

When you are painting a large group, if one or two figures are depicted in more detail, the rest can be dealt with quite loosely for the group to 'read' correctly. Body language will say a lot about a group of people, and photographs are extremely useful to 'freeze-frame' movement. It is intriguing to see the

shapes the moving body makes, though these sometimes need to be modified to make the figure look 'normal'. Photographs can be useful to capture fleeting light effects as well as movement, though they should only be used as a guide as shadows can blacken, and light areas may bleach out.

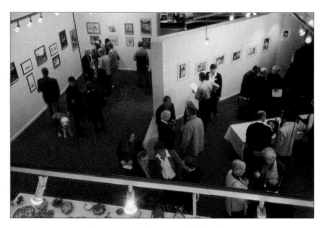

The source photograph for the picture opposite.

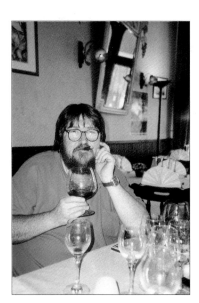

Bernie
Fussy details were removed and the source photograph cropped.

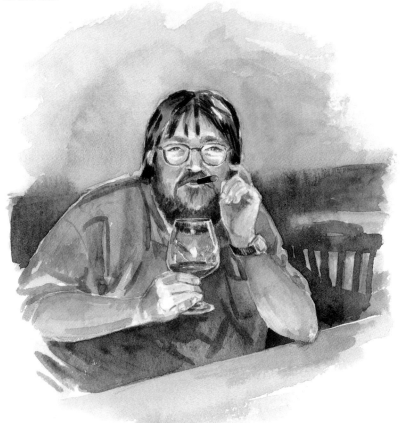

28

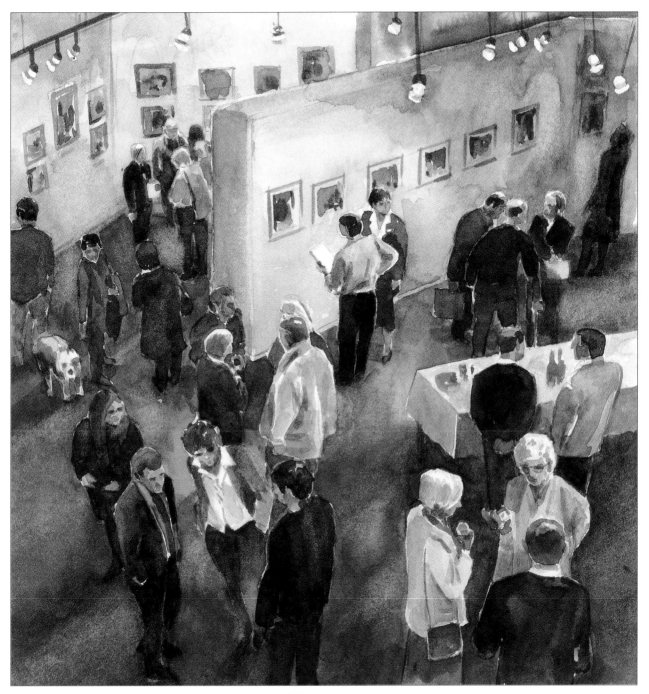

Exhibition Preview

This overhead viewpoint makes an interesting composition. Seen from above, the figures are foreshortened, the heads appearing quite large, with the chin well down into the chest. The top half of the body is larger in proportion to the legs and lower body.

Girl at work

This project has been left deliberately loose and simple, but it is easy to add more detail if you prefer. I used only one brush throughout the project, and left areas of un-worked paper to provide highlights rather than using masking fluid. Before beginning, I made a rough sketch to work out the tones in the composition.

I made a fairly detailed sketch of the girl at her desk. I liked the effect of light streaming in from behind the figure, and the way the curves of the human form with the soft, flowing hair contrasted with the angular lines of the technological elements (the furniture, books and computer). I often make written notes on my drawing to describe the colours of different elements of a painting.

You will need:

Watercolour paper: 140lb (300gsm) Not

No.8 brush with a good point

Pencil

Putty eraser

Rule or straight-edge

Watercolour paint:
 cadmium red; lemon yellow; cadmium yellow; French ultramarine; cerulean blue burnt sienna; indigo

The initial rough sketch shows the tones in the composition.

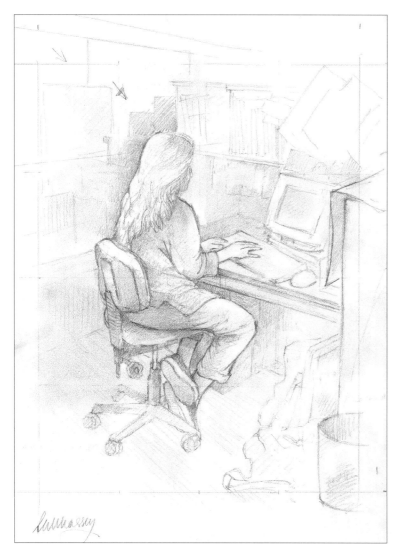

The detailed sketch I worked from.

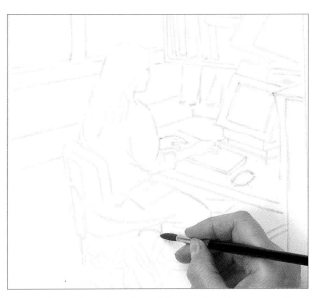

1. Trace the image down on to the watercolour paper using a hard pencil and a rule for the straight lines. You can also use a squared grid to transfer the image if you find this easier.

2. With wash B (cerulean blue and cadmium red), redraw the outline. Let it dry, then gently rub out the pencil lines. Take care not to press too hard; it may damage the paper's surface.

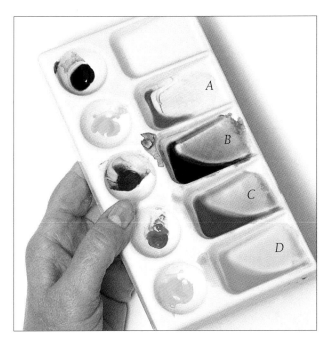

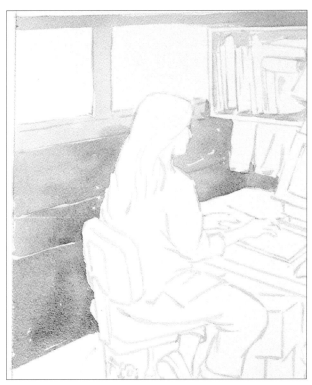

3. Mix up a range of basic washes:
A) Cadmium yellow and cadmium red with a touch of ultramarine for skin tones.
B) Indigo and burnt sienna for darker areas.
C) Cerulean blue and cadmium red for greys.
D) Lemon and cerulean blue for lighter areas.

4. Using a No.8 brush, work on the background first, keeping it loose and light. I used a pale wash of B to put in the background grey tones.

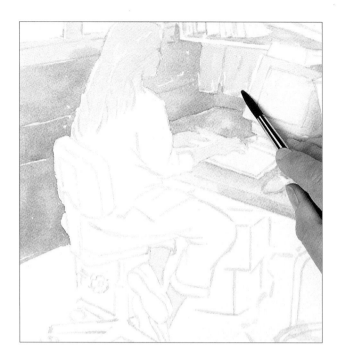

5. Put in the hair, face, hands and ankles using a pale wash of A. With wash D, put in the computer screen and desk. Take care to leave hairline gaps between adjacent washes. Paint in the notelets using yellow and green tones.

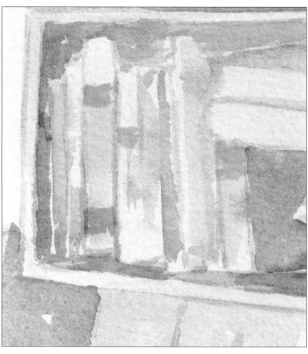

6. Paint in the books, varying the tones and letting them run partially in to one another. Add touches of plain burnt sienna wash where appropriate.

TIP You can let the paper do much of the work of producing interesting texture across your painting.

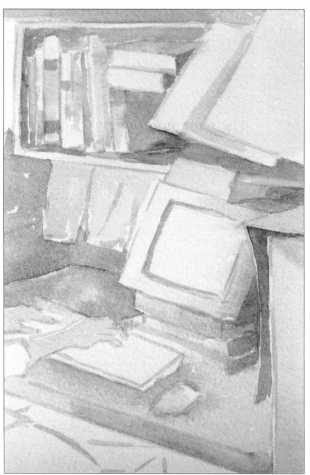

7. Paint in the boxes using washes of burnt sienna, indigo, and cerulean blue. Use wash mix B (indigo and burnt sienna) from your palette for the shadow in the foreground on the filing cabinet. Put in some of the keyboard detail using the same mix.

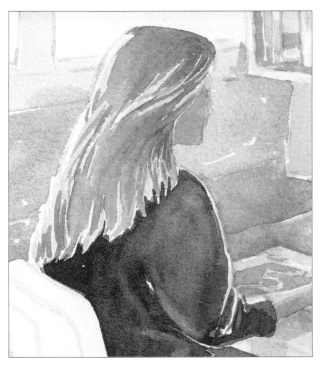

8. Paint in the girl's hair, using tones of burnt sienna, adding in a little indigo in places. Paint the jumper using indigo, varying the concentration of the wash to produce different tones. Reserve some strong highlights by leaving areas of the paper un-painted.

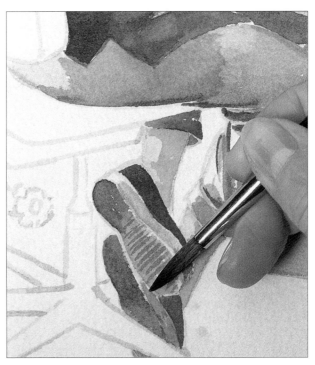

9. Paint the trousers using a pale wash of cerulean and indigo. Put in the uppers of the shoes using indigo, and the soles with a pale wash of mix C. Use a deeper concentration of the same mix to add fine lines to the soles with the point of the brush.

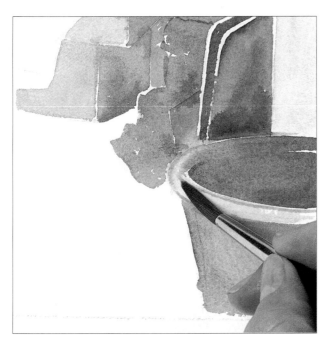

10. Paint in the waste bin and the red carrier bag in the foreground using cadmium red with a touch of ultramarine or indigo added.

33

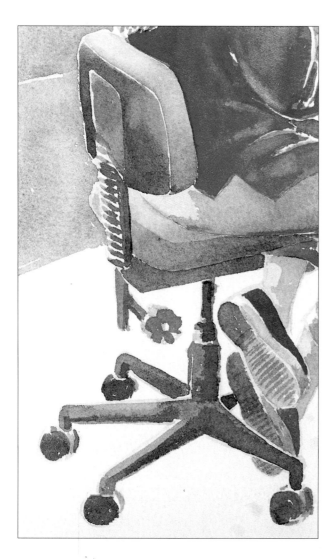

11. Paint in the chair and cushion in cadmium red with a little indigo added, diluting it to paint in the pale areas where it catches the light. Use indigo with a tiny amount of red added for the dark grey areas of the chair, adjusting the strength of wash where appropriate and taking care to leave gaps for the reflected light.

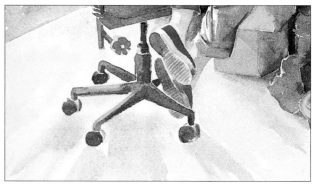

12. Paint the shadows on the floor quite loosely with wash C. Fill in with a very pale wash of lemon and cerulean blue, allowing them to run in together.

13. Paint in the computer screen using indigo with touches of cadmium red.

Opposite
The finished painting
The details of the hair have been sharpened up and blended in to the jumper so there are no white gaps.
310 x 220mm (12 ¼ in x 9 ½ in)

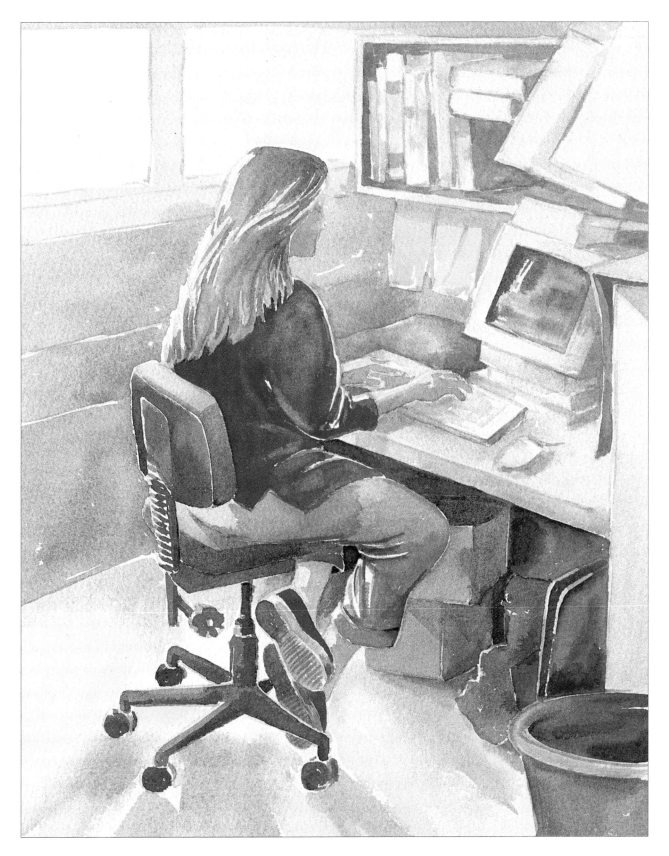

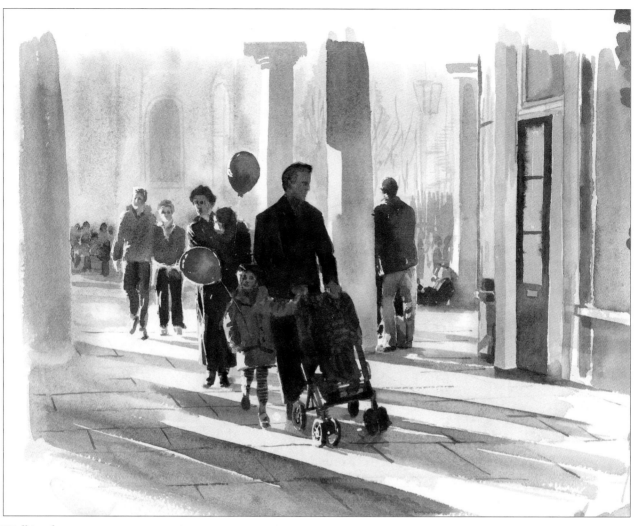

Walking home

I loved the children's bright red balloons caught in the pale winter sunlight. The contrast between the semi-silhouetted figures and the long slanting shadows gives a sense of space. I masked out some of the finer highlights on the balloons, the figures and the pushchair, and used a wash of cerulean blue and burnt sienna for the simplified background and the foreground shadows.

Note

When feet are on the ground, the shadows are attached, and blend in with the figure. When feet are lifted there is space between them and the shadow, which is a good indication of movement. See also the picture of the ballet dancer on page 27.

Evening Stroll

This study of people taking a stroll or chatting in the pale evening sunlight was based on a photograph, which arrested the movement and also caught the dramatic contre-jour effect, looking directly into the light source, which throws the figures into partial silhouette. I increased the tonal range by lightening the colour of the paving while adding a lot more colour into the figures, making those in the foreground darker and more detailed than the smaller, paler figures in the background which merge into the distance.

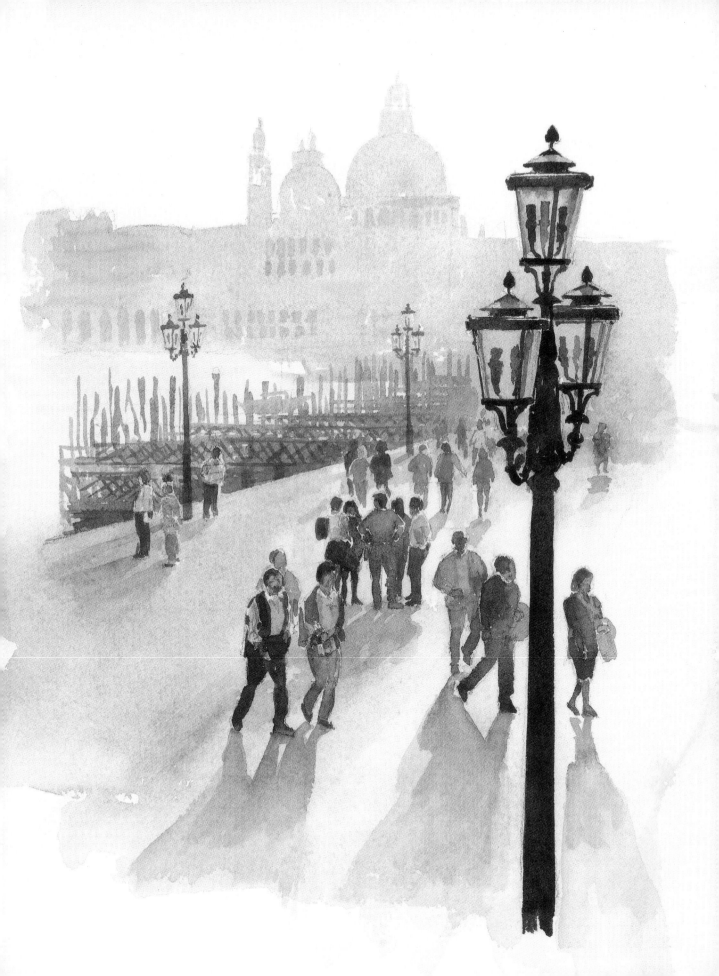

Jump

This project illustrates how invaluable the camera is for capturing that split second in time. I was on holiday when I took photographs of this mother playing with her daughter as she jumped over the waves.

Sunlight falls on the right side of the figures, creating very bright highlights on the skin. The mother's skin tones are a little darker than the child's, but similar colours and techniques are used for each. I used a photocopier to enlarge the image, but this could also be done using a squared grid on tracing paper.

The backdrop should set the figures off, not compete with them, so it is important not to make it too busy. If it looks too wishy-washy when it has dried, more waves can be created using a 'dry brush' effect.

Build in contrast to help the figures stand out by using darker tones against light skin tones and lighter background tones against darker areas of skin.

You will need:

Tracing paper
Tracing-down (transfer) paper
Masking tape
Watercolour paper: 140lb (300gsm) Not, stretched
Technical pen
Tinted masking fluid
Dip pen
Silicone shaper
Pencils: 2H and B
Putty eraser
Palette
Round brushes: Nos. 8, 10, 20
Watercolour paints:
 raw sienna, burnt sienna, alizarin crimson, light red, cadmium red, phthalo blue, French ultramarine, cadmium yellow, lemon yellow, permanent rose

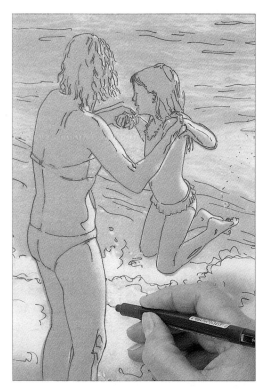

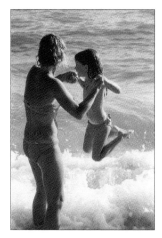

The source photograph. Only an impression of the sea is needed, so you need not follow the photograph too slavishly.

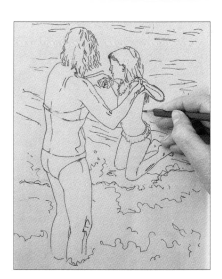

1. Enlarge the source photograph using a photocopier. Tape the copy to a drawing board and outline the figures with a technical pen so the lines will show clearly through tracing paper. Lay on the tracing paper and trace the outlines, referring to the original photograph for any details which may not be clear on the copy.

2. Checking the copy against the photograph, draw in any details which are not clear. If necessary adjust the composition; for example, I have moved the girl's hand away from her chin.

38

3. Using transfer paper and a 2H pencil, trace down the image on watercolour paper which has previously been stretched, taking care not to press too hard. Check that all the drawing has come through, using a 2B pencil if necessary to draw in any missing details. Pencil lines will be erased later.

4. Referring to the source photograph for guidance, use a fine dip pen and masking fluid to reserve the brightest highlights on the hair and the skin, particularly where the light catches the fingers.

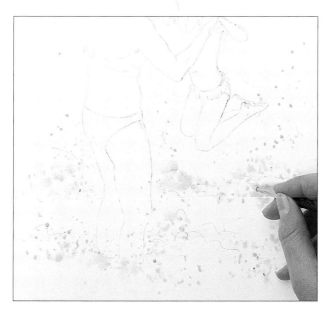

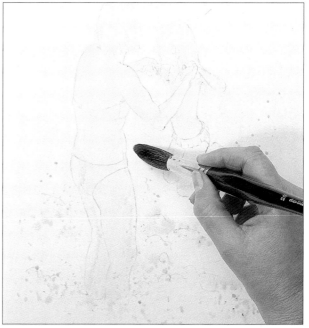

5. With a small silicone shaper, dot in specks of masking fluid to represent foam. Use your finger to smudge some of the blobs of masking fluid to give a rough effect for the top of the surf. Let the masking fluid dry completely before you start to paint.

6. With a No.10 brush, paint a medium-strength wash of raw sienna over the figures to achieve the 'glow' of sunlight on skin. Dilute the same wash and paint it over the sea area with a No.20 brush. This will take the starkness off the paper and will also reduce its absorbency. Leave your work to dry.

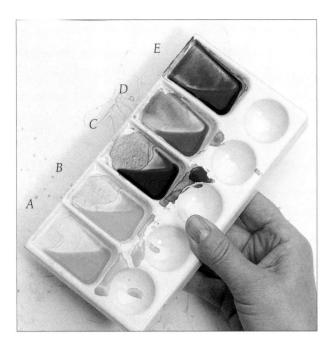

TIP Test the colours to see if they are the right shade and intensity on a 'test strip' down one side of your painting before applying them to your work.

7. It is vital to work quickly when you are adding colours wet-in-wet, so prepare the main washes for the figures in advance:

A Raw sienna and light red for the main skin colour.
B Cadmium red and cadmium yellow for the 'glowing' skin tones made by reflected light.
C Alizarin crimson and ultramarine for the areas of shading.
D Burnt sienna for the darker skin tones.
E French ultramarine and burnt sienna for the hair.

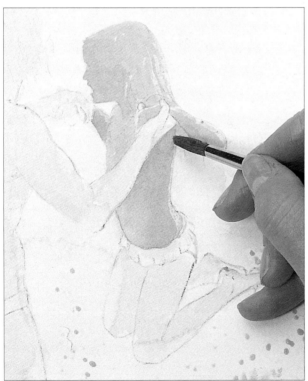

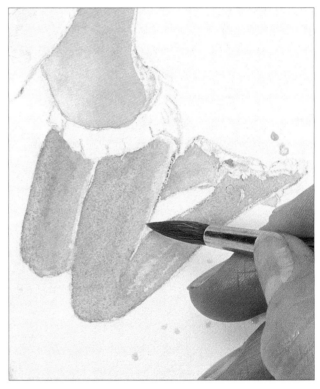

8. Beginning with the girl, using a No.8 brush and working wet-in-wet, paint in small, controlled areas starting with the pale tones. Use wash A (raw sienna and light red) for the head, face and arms and wash D (burnt sienna) for the darker area.

9. With the same brush and colours, and still working wet-in-wet, paint in the girl's legs. Work on each leg separately and leave a hairline gap between. Start with the pale tones and put in the shading around the knee with wash C.

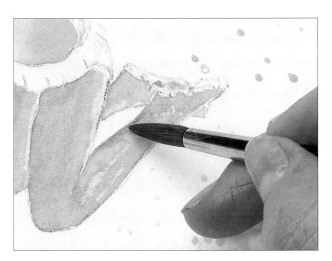

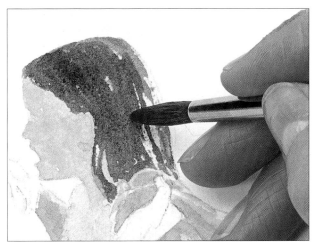

10. Put in a little permanent rose on the heels and the calf of the nearest leg, to suggest reflected colour from the girl's bikini bottom, blending it in with mix A for the feet.

11. Damp down the head area with plain water if necessary and use mix E to paint in the hair. Rinse the brush and squeeze it out, then lift off highlights down the back and in other areas as necessary.

Make sure you stir the shadow wash thoroughly as darker pigment is prone to separation.

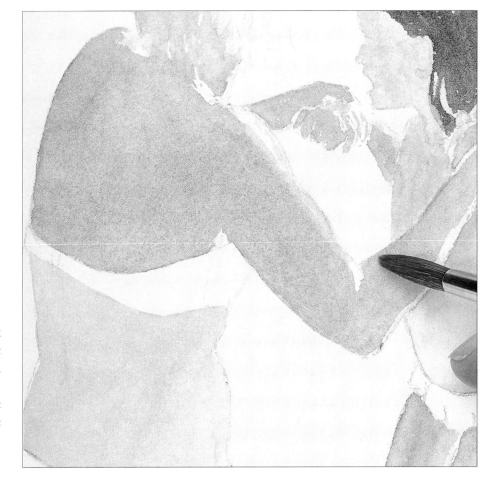

12. Using mix A, paint over the whole of the mother's body to deepen the basic skin tone. Working wet-in-wet, use mix D to build up the tones on the shoulders, arms and hands.

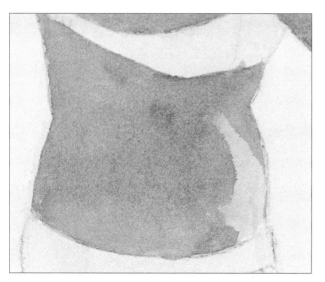

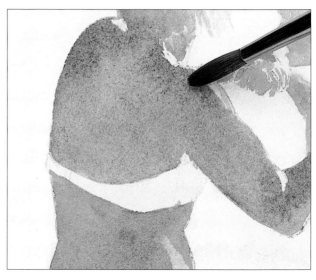

13. Complete the mid-torso using the mixed skin tones from your palette, using mix A only for the lightest part on the right.

14. Use mix C to build up darker tones across the shoulders, blending with plain water if necessary.

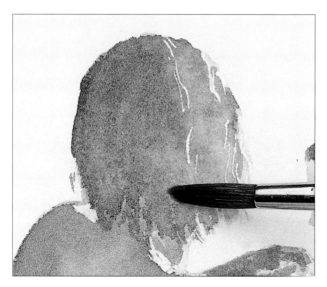

15. While the head is still damp (not wet) use mix E to paint in tones on the hair.

16. Paint in the legs using mixes A and D, adding in mix C at the base of the legs, and around the leading knee.

18. Paint in the girl's bikini bottom with permanent rose, adding a little ultramarine for shading in the darker areas.

17. When the skin washes are dry, paint in the light area of the mother's bikini with a pale wash of phthalo blue and lemon yellow. Add a little more phthalo blue to the wash for the darker areas. **Note**: the bikini top fastening has been lifted out with a clean brush.

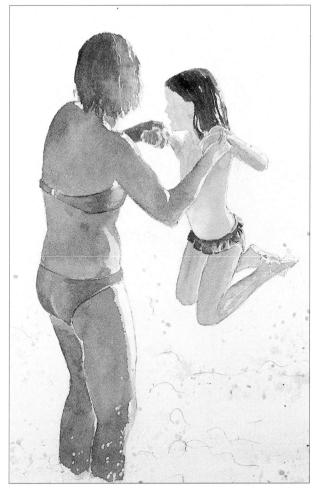

19. When your work is dry, assess the tonal contrast of each figure and adjust the shading where necessary.

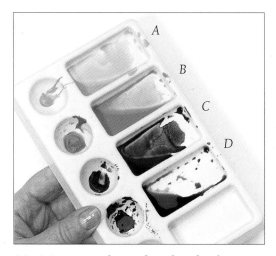

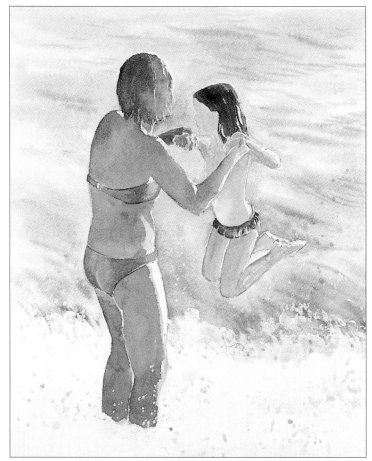

20. Mix up a palette of washes for the sea:
A) Raw sienna B) Cerulean blue
C) Phthalo blue D) French ultramarine.

21. Using a No.10 brush, damp the sea area with plain water down to the surf, working carefully round and between the figures. Paint in the sea area starting at the top with wash mix B and adding in touches of mix A and then C, using more C towards the foam.

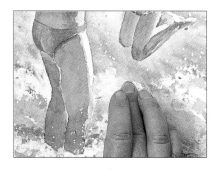

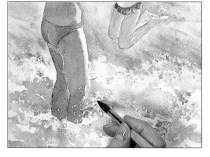

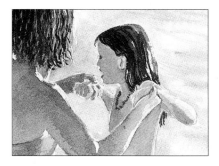

22. Using your fingers, create tones in the foam with a dabbing motion, using the same colours and changing shades as appropriate. Add a tiny amount of cadmium red to cerulean blue to create grey tones, and also use a little burnt sienna to paint round the mother's legs. Leave your work to dry.

23. Create wave effects on the sea using strokes of mixes B and C, reassessing the area as it dries to see if it needs any more work.

22. Put in the girl's features, the tendrils of hair on her back and the tuft of hair on her forehead, darkening the hair if necessary.

The finished painting

When the painting was completely dry, I removed the masking fluid and tidied up the ragged edges between the sea and the figures, checking that I was happy with the details and adding small finishing touches where necessary.

310 x 220mm (12 ¼ x 9 ½ in)

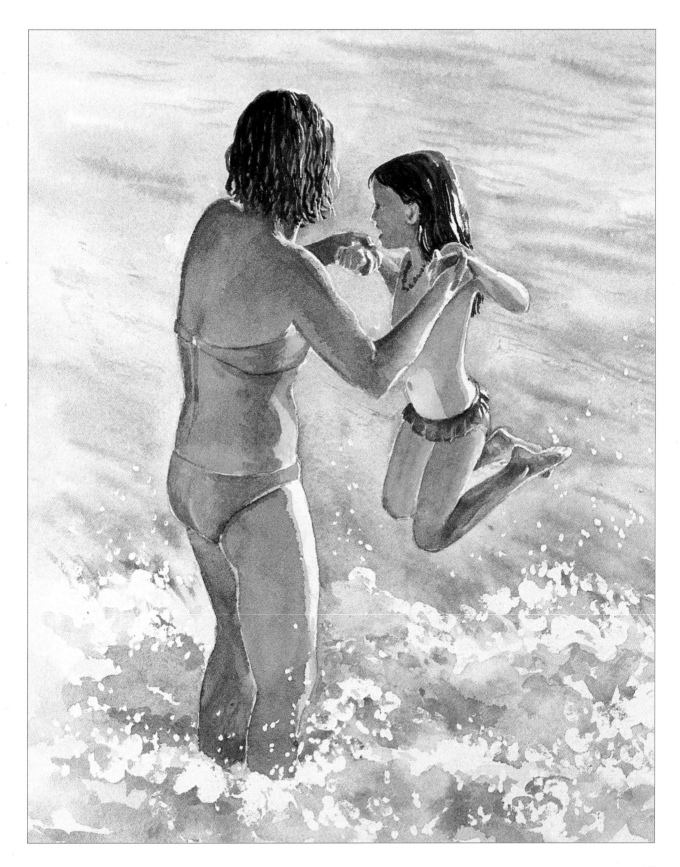

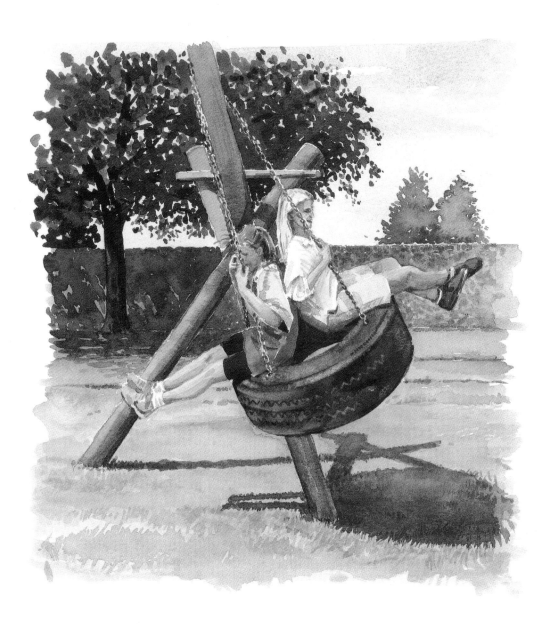

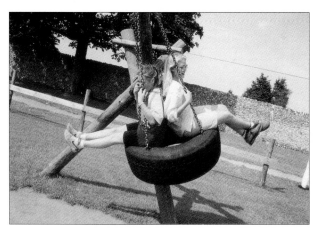

Swinging
The camera has been able to freeze the momentum of the girls swinging on the tyre. The strong background tones of the tree and cast shadows help to frame and emphasise the subject.

Watch the Birdie!
In this painting, I was able to capture a magic moment using a combination of photographs to achieve the best expression and composition.

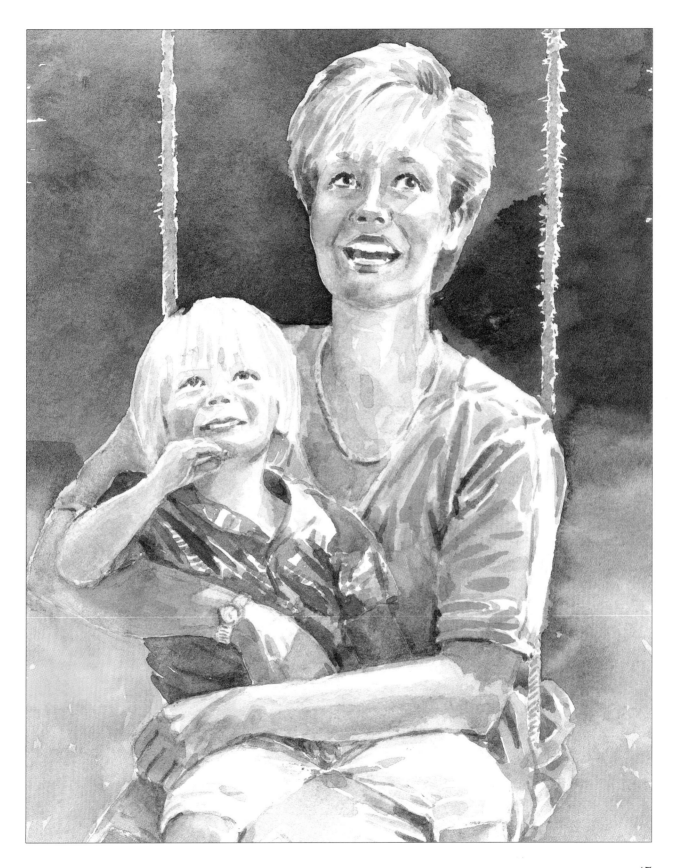

Index

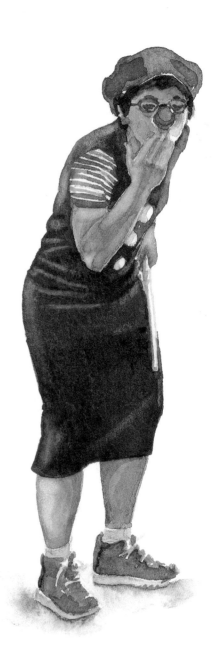